THE ILLUSTRATORS

---

# Oliver Jeffers

Martin Salisbury

THE ILLUSTRATORS

# Oliver Jeffers

SERIES CONSULTANT QUENTIN BLAKE
SERIES EDITOR CLAUDIA ZEFF

90 ILLUSTRATIONS

T&H

*once there was a boy...*

**FRONT COVER** Vignette, *Lost and Found*, 2005
**BACK COVER** Jeffers in his studio, Northern Ireland, 2021. Photograph courtesy of Yasmina Cowan
**FRONTISPIECE** Jeffers working on *The Fate of Fausto*, Idem Editions, Paris, 2018
**ABOVE** Student dummy, *How to Catch a Star*, c. 2000
**PAGE 111** Vignette, *Once Upon an Alphabet*, 2014
**PAGE 112** Interior page, *Meanwhile Back on Earth*, 2022

First published in the United Kingdom in 2025 by Thames & Hudson Ltd, 181A High Holborn, London WC1V 7QX

First published in the United States of America in 2025 by Thames & Hudson Inc., 500 Fifth Avenue, New York, New York 10110

Oliver Jeffers © 2025 Thames & Hudson Ltd, London
Text © 2025 Martin Salisbury
Works by Oliver Jeffers © 2025 Oliver Jeffers
Reproduced covers/layouts featuring art by Oliver Jeffers © 2025 the respective owners

Designed by Therese Vandling

All Rights Reserved. No part of this publication may be reproduced or transmitted in any form or by any means, electronic or mechanical, including photocopy, recording or any other information storage and retrieval system, without prior permission in writing from the publisher.

British Library Cataloguing-in-Publication Data
A catalogue record for this book is available from the British Library

Library of Congress Control Number 2024943721

ISBN 978-0-500-02815-5

Impression 01

Printed and bound in China by C&C Offset Printing Co. Ltd

Be the first to know about our new releases, exclusive content and author events by visiting
thamesandhudson.com
thamesandhudsonusa.com
thamesandhudson.com.au

FSC
www.fsc.org
MIX
Paper | Supporting responsible forestry
FSC® C008047

# CONTENTS

Introduction 6
Early childhood and schooling 12
Art school 18
How to catch a publisher 24
Breaking out: the first ten years 32
Neither here nor there: artist
as illustrator / illustrator as artist 62
Collaborations 66
A bigger picture: the existential picturebook 83
The future 104

Chronology 106
Select bibliography 108
Acknowledgments 109
Contributors 109
Index 110

**OPPOSITE**
Mural painted by Jeffers,
Belfast, 2014

# 'We are a story-driven species'

OLIVER JEFFERS

## Introduction

In 2021, Oliver Jeffers attended the COP26 United Nations conference on climate change in Glasgow, having been invited as a participant. The organizers issued him with a plastic identity card, which – alongside a photograph of his smiling face – featured the words 'Observer/Translator'. While his first thought was 'Why is there not a category for "artist"?', it occurred to him that this was perhaps as apposite a description of 'what I do' as anything he himself had previously managed to come up with. The convenient boxes into which we like to separate 'illustrator', 'painter', 'fine artist', 'author', 'performer' and the rest have never sat comfortably with the prodigious output of this particular creative practitioner.

    Since leaving art school in 2001, Jeffers has played a significant role in elevating the practice of illustration, especially picturebook-making, to new levels of appreciation and acclaim. He first came to prominence with *How to Catch a Star* (2004), a picturebook that was developed from his graduation project. To date, his books have been translated into 50 languages and have sold over 15 million copies worldwide.

Over little more than two decades, Jeffers has swept like a hurricane through the worlds of illustration and fine art, breaking down barriers and tearing up rule books in the process. Nowhere is this more keenly felt than in the field of publishing, of course, where he has challenged long-held notions about picturebooks: expanding our perception of what constitutes suitable subject matter, for example, or the age range of the audience that a picturebook will appeal to. In recent years, the themes within his work have become increasingly ambitious and questioning in nature, often exploring our existence on, and care for, Planet Earth. This thematic shift has taken Jeffers in many directions, from film spin-offs of his picturebooks, TV appearances, collaborations with rock stars and quantum physicists, to fine-art projects, sculpture trails and installations.

Historically, the author has taken the lead in children's publishing, with the illustrator often playing a subordinate,

**ABOVE AND OPPOSITE**
Sketchbook pages, 2003–7

**OVERLEAF**
Sketchbook pages, 2014

albeit collaborative role. In rejecting this traditional model in favour of the all-encompassing artist/illustrator/author/picturebook-maker, Jeffers has helped to open up new possibilities for expressive artists across both the fine and applied arts. A constant for him, in all these endeavours, is a relentless spirit of optimism, the pursuit of beauty in simplicity and a belief in humanity's ability to overcome the challenges we face, however daunting. Through the medium of the picturebook, he has consistently sought to illustrate the power of hope, the simple positive truths that can so easily be overlooked or drowned out in the modern world, seemingly filled with noise and anger. Brought up amid the noise and anger of Belfast, at a particularly turbulent time in the city's history, Oliver Jeffers now employs his ability to empathize with opposing voices and forces to underpin much of his work.

NO THEM ONLY US

**Early childhood and schooling**

In the 1970s, the Australian Assisted Passage Migration Scheme was nearing the end of its lifespan. Widely associated with the term 'Ten Pound Poms', the scheme had been set up immediately after the Second World War to encourage British subjects and their dependants to migrate at a beneficial rate as part of the 'populate or perish' policy instigated by the then-government, led by Prime Minister Ben Chifley. It would be wound up in 1982.

 To Paul and Marie Jeffers in strife-ridden Belfast, where the violence that ravaged Northern Ireland during the Troubles was at its worst, the promise of a new life of sunshine, peace and prosperity must have seemed an opportunity too good to miss. Partly influenced by the advice of a friend, along with, no doubt, the ubiquitous posters of manicured lawns and whitewashed houses, they decided to embrace a new life on the other side of the world. The reality of the migrant camps that awaited them has been well documented and dramatized, but they resolved to make a go of it. Both Paul and Marie had been university-educated and were able to get work in Brisbane, Paul as a teacher and Marie as a nurse. On 5 October 1977, two years after the birth of his older brother Rory, Oliver Brendan Jeffers arrived, in the heat and dust of the northwestern Australian mining town of Port Hedland, where the family were now based. Had it not been for the fact that Marie was showing early signs of multiple sclerosis, it is likely that Oliver and Rory would have grown up in Australia, but the symptoms (only later diagnosed as MS) persuaded the family to head back to Northern Ireland a few months after Oliver's birth. He still, however, carries an Australian passport.

 Back in Belfast, the young Oliver Jeffers began to consume comics and, like many illustrators, cites them as his earliest inspiration and influence. He would spend many happy hours copying characters from the *Asterix* books, carrying huge bundles of them home from the local library. Even today, he says, he wonders whether the way his characters run across the pages of his books 'with those bendy legs' might owe something to *Asterix*'s illustrator, Albert Uderzo. Other early influences included Charles

**ABOVE**
Oliver with his mum, dad and brothers, early 1980s

Schulz's *Peanuts* and Jean-Jacques Sempé's illustrations for *Le Petit Nicolas* – a comic strip that developed into a series of children's books, created with René Goscinny. In reality, though, Jeffers was as interested in playing out in the streets as poring over books indoors. Football was his passion. In fact, if you had asked him to name his dream job as a 6- or 7-year-old, he would have said 'a designer of football kits' – inspired not only by his love of the sport and of drawing, but also the garish kit designs of the 1984 UEFA European Football Championships.

The first picturebook to resonate with the young artist was Eric Carle's *The Bad-tempered Ladybird*, originally published in 1977. The book follows a grumpy ladybird as it challenges a series of larger and larger animals to a fight, finally meeting its match – a whale – and learning the value of kindness. Jeffers clearly remembers scrutinizing the imagery and trying to make sense of the enormous contrasts of scale between the whale and the ladybird.

It was an image that stuck with him, and he acknowledges it played a part in the way he exploits extreme contrasts of scale in his work to this day. Gradually, he began to learn that drawing could get him out of some of the less enjoyable aspects of school; for instance, he was recruited to help with the production of sets for school plays. Only one example of his childhood drawings seems to have survived, executed at the age of seven and only recently coming to light, having turned up at the home of an aunt. 'I don't really know what any of my childhood drawing was like because my dad was not, shall we say, a collector,' he recalls. 'Everything just got chucked in the bin.'

In 1990, Oliver and Rory received a scholarship to travel from Belfast to Camp Dudley in Westport, New York, in large part thanks to encouragement from their father. It was at Dudley summer camp that many close and lasting friendships were forged, with artist and director Mac Premo, a future collaborator, among them. Jeffers feels strongly that his experiences at the camp, which he attended twice,

**ABOVE LEFT**
Oliver at his tenth birthday party, 1987

**ABOVE RIGHT**
Oliver with his older brother Rory, early 1980s

**OPPOSITE**
Oliver with friend and collaborator Mac Premo, 2003

in successive years, in many ways changed the course of his life, and were it not for his time there, he may never have found himself working as an artist in Brooklyn in later years.

Paul and Marie Jeffers were forward-thinking liberals. Paul was a teacher at a school for children who were, in Oliver's words, 'one step away from prison'. He later moved into teaching children with severe physical disabilities. But he was always interested in progressive education. In the early 1980s, schools in Belfast were heavily segregated along Catholic and Protestant lines. The Jeffers heard that a new, integrated senior school was about to open, Hazelwood Integrated College, which they felt strongly would be right for Oliver and Rory. 'Neither of us showed any academic promise,' Oliver says, 'but my dad instilled in us his belief that "remembering a lot of facts only proves that you've got a good memory. It's the presence of curiosity and imagination that's the key to intelligence."' Paul valued the ability to hold two opposing ideas in your head simultaneously and was keen to nurture this quality in his own children. However, the integrated education system faced its challenges, with many parents unwilling to put their children into schools like Hazelwood Integrated College. To qualify for basic funding from the government, the school had to start taking in children who had been excluded from other schools. As Jeffers explains, 'It was the roughest, toughest environment…including people who are now either dead or in prison for killing someone else, and that is not an exaggeration! Consequently, very little attention was paid to academic learning – it was seen as uncool to do so.' In more recent times, the school has won awards for its pioneering work in breaking down sectarian boundaries.

Teaching in such conditions must have been exceptionally difficult, but Jeffers was encouraged at school (and, of course, at home too) to pursue his interest in art. With hindsight, he wonders whether the environment in which he found himself actually worked in his favour. Years later, when he met his wife, Suzanne, who, in his own words, 'went to a "decent" school and had never met anyone who didn't have a "proper job"', he realized that he had inadvertently fallen into a system that rewarded him for his artistic inclinations:

> *And the reason why I got away with that, in a school that was basically full of really tough kids, was that no one picked on me for showing an interest in art because there was value to them in me doing art for them – like making decorations for their skateboards or writing their favourite band's name on their school bags…. And so, I was encouraged by my teachers for showing an interest in anything at all, and encouraged at home, in this weird set of circumstances that would not have happened otherwise, [in another school that] would not have remotely rewarded art in the slightest.*

All of this, of course, took place against a backdrop of some of the worst sectarian violence, prior to the signing of the Good Friday Agreement on 10 April 1998. Jeffers saw bombs go off, and people he knew were imprisoned or killed. In an interview with Steven Heller for *PRINT* magazine in 2018, he recalls the loss of innocence that comes with witnessing such atrocities: 'You become savvy. You know what to say and to who. You learn what not to say and those to avoid, where not to go and when.' The teenage Jeffers can be seen speaking about such matters while a student at Hazelwood, in the 1994 fly-on-the-wall documentary *Belfast Lessons: Inside the Peace Process*, a collaboration between the French production company Point du Jour and Channel 4. He appears regularly throughout the film, which was originally broadcast on TV as a series of shorts: he is seen playing basketball and sharing his thoughts on the Troubles; he speaks of his reluctance to 'take sides', and his hopes for peace in Northern Ireland as he celebrates his

seventeenth birthday surrounded by his family, including his ailing mother and his father Paul. Paul also appears in the film, expressing his views on the need for the people of Belfast to find agreement among themselves, rather than via external forces. In one of the most poignant scenes, we hear a poem that Oliver has written about the Troubles. As he reads the rhyming couplets out loud, the manuscript is shown on-screen: handwritten in capital letters, with daubs of paint depicting explosions and fires – an early indication of his fearless ability to address issues of conflict through words and pictures.

Jeffers clearly recalls the moment at school when he discovered that there was a thing called 'art college', remembering it as a comedic experience, the careers advisor having low expectations and the pupils seemingly concerned primarily with the question 'How can we make this guy cry?':

> *Imagine* Derry Girls *but mixed with juvenile detention, i.e. cheeky people who were actually dangerous. So the careers advisor would say, 'Well, what are you interested in?' And I was like, 'Er… drawing pictures?' And I suppose it was just in a sort of dismissive way he said something like, 'Well, I suppose you could go to art college.' And I was thinking, 'What, that's a thing?'*

This realization spurred him on to take GCSE art. He was confident that he had some talent, even if he felt frustrated that he couldn't always make things look how he wanted them to look on the page. But the ideas were strong, and there was an energy and charm to the drawings. Even at this early stage in his artistic development, Jeffers was conscious of being more concerned with concept than the craft of drawing, but he now had a clear objective: to get into art school. By the time he took his A-levels, he had already secured a place at Belfast School of Art, part of Ulster University. 'I kind of took my eye off the ball really because I had an unconditional offer from the art school, so I didn't really try,' Jeffers admits. 'And that set a bad precedent for me for a while.'

**OPPOSITE**
Illustrated poem, created and read out by Jeffers in *Belfast Lessons: Inside the Peace Process*, 1994

## Art school

Belfast School of Art was established in 1849, during a period of immense change and expansion in art education around the British Isles. The Great Exhibition of 1851 in London sparked a lot of soul-searching as to whether standards of art and design in Great Britain were quite as 'superior' as had been confidently assumed, galvanizing efforts to improve both the teaching of art and education facilities. Art schools quickly sprung up around the regions and remained autonomous until the majority were absorbed into the polytechnics in the 1980s, prior to the distinction between polytechnics and universities being abolished as a result of the 1992 Further and Higher Education Act.

When Jeffers arrived at Belfast School of Art, in 1997, the 'bad precedent' quickly manifested itself in the form of apathy and cynicism. He had underestimated the cultural leap between the prescriptive, exam-orientated approach to teaching at secondary school and the predominantly self-structured learning of contemporary university curricula, especially in the art-school sector. Like many art students, he was surprised by the lack of instruction in practical, technical and professional practice skills – an aspect of teaching that has largely fallen away since the absorption of art schools into university culture:

> *It was very easy for someone like me, who wanted to get away with doing nothing, to just glide through unnoticed. At art college I was kind of pulling the wool over everyone's eyes because I was getting away with doing just enough to get a mark and I was thinking, 'Well, you're all suckers!' because I was getting away with doing as little as possible and I thought, 'I don't have to go in, I'm getting by.'*

By the end of his second year, he had decided to take time out: to travel around the USA and then on to Australia. He got as far as Sydney before running out of money, so he took a job in a bar. The intention had been to see if he could make it in Australia as an artist–illustrator, but it soon became apparent that, in his own words, 'getting by with 41% didn't

**OPPOSITE**
Original sketches for Jeffers's graduation project, *How to Catch a Star*, c. 2000

OLIVER JEFFERS

How to catch a star

pondering

How to catch a star

The stereotypical spaceship from TINTIN
I tried to build one like this when I was wee.

**ABOVE**
Jeffers at his graduation show, Ulster University, Belfast, 2001

**OPPOSITE, ABOVE LEFT**
Student sketchbook for *How to Catch a Star*, c. 2000

**OPPOSITE, ABOVE RIGHT**
Rough poster design for an exhibition at the Ormeau Baths Gallery, Belfast, 2004

**OPPOSITE, BELOW**
Cover of Jeffers's debut book, *How to Catch a Star*, 2004

of talent or effort – something he describes as 'that Hollywood thing'. For some time, he had been toying with a project that had been loosely conceived during his year out, moving compositional sketches around, experimenting with various permutations and relationships between words and pictures, and how they might influence each other's meaning. He had originally thought of them as freestanding paintings, but it soon dawned on him that these connections were key characteristics of a picturebook. He came up with a story about a boy who loved stars, and who yearned to catch one of his very own and make it his friend. It was titled *How to Catch a Star*, and it won him a first-class honours degree.

## How to catch a publisher

Suddenly finding himself in the 'real world', Jeffers managed to sell paintings and pick up the odd illustration commission, enough to buy him time to further refine his picturebook project. He had set his sights on finding a publisher when he happened to spot a copy of the *Writers' and Artists' Yearbook* in a bookshop. He scoured the section on how to get published and quickly realized that he needed to go the extra mile if he wanted to stand out from the crowd. Although confident that his book was publishable, he researched the market, familiarizing himself with picturebooks in shops to try to assess which publishers might be most suitable to approach. He decided to have a dozen or so dummies of the books made up by a Belfast printer and post them out to ten carefully targeted commissioning editors. There was just one problem: like most new graduates, he was broke. Determined not to let this get in the way, Jeffers took an audacious approach by offering the printer a deal: he would give them one of his paintings in return for the printer producing the dummies. The proposal was accepted, and soon the dummies were on their way to the selected publishers. Reflecting on this period, Jeffers says:

**BELOW AND OPPOSITE**
Vignettes, *How to Catch a Star*, 2004

**OVERLEAF**
Original artwork, *How to Catch a Star*, 2004

*I suppose I have always tried to 'be the river, not the rock'. So, if there is something I want, I try to find a way. 'No' doesn't have to mean no, it just means that that route is not necessarily going to work. So ultimately, then, some projects do happen, against the tide. But sometimes projects don't happen, so I just try to find another way or stumble upon another project.*

It can take months for publishers to work through submissions, and Jeffers had fully expected a long wait. However, within a couple of days he heard back from two publishers, HarperCollins and Penguin US, with whom he has continued to work ever since. The publishers needed reassurance about whether he was willing to make changes and develop the original idea. The potential was clear to see, but some of the artworks were more 'mature' in their execution than others. Jeffers's response was: 'Absolutely!' The transformation from the initial student dummy to the fully functioning 32-page picturebook was, as is always the case, a journey that involved close collaboration with editors and designers.

26

OLIVER JEFFERS

Acknowledging the emphasis in his work on concept over craft, Jeffers says that he has taught himself just enough about each of the various media and materials he has employed to allow him to express the narrative concept as minimally and with as little extraneous decorative distraction as possible. *How to Catch a Star* was executed through the notoriously technically demanding medium of watercolour. The visual elements – boy, star, tree, flat washes of land and sky – are cleverly organized through the exploitation of scale to create maximum graphic tension as we follow the boy on his quest. The boy is simplified almost to the level of an emoji, with just enough in the way of facial features to register basic expressions. The flatness of the washes is crucial to the representation of space:

> *I'd never used watercolour before I'd started using it for* How to Catch a Star, *but in the process of doing that first version at university and then the second for the publisher, I gradually felt like I knew what I was doing. I didn't read any instruction manuals or anything, I just intuitively made it work for me.*

As with any technique, the tacit knowledge or 'muscle memory' acquired through the process of handling a particular medium, or combination of media, will inevitably lead to greater assurance and control. This is evident across the four subsequent books in the series featuring the character only ever referred to as the 'boy': *Lost and Found* (2005), *The Way Back Home* (2007), *Up and Down* (2010) and *Where to Hide a Star* (2024). Jeffers explains:

> *Watercolour is a tool at my disposal to make a thing that I want to put out into the world, but then with time I gained a little more finesse in figuring out how I use watercolour and what it could do for me. And the results were a massive improvement, and you know, if you look through* How to Catch a Star *right through to* Where to Hide a Star, *you'll see the improvement in my technique with using watercolour, just from experience. Instruction manuals will tell you 'how it's done', but that*

*doesn't mean that it's going to be the best way for you to use it; you have to get your hands dirty and figure out what this thing is to your own best interests.*

This mindset, a pragmatic approach to method across a range of media, has carried through into Jeffers's later incorporation of collage into his picturebooks, both handmade and digital, and oils for painting.

The question 'Where do your ideas come from?' is often one of the first to be asked by both children and adults when a picturebook-maker faces questions from audiences at a public event. Sometimes it is a variation of this: 'Which comes first, the words or the pictures?' – to which Jeffers would typically respond, 'Neither. It starts with a "feeling".' The unique nature of the picturebook medium means that, for many makers, this early sense of a visual and verbal theme is not always easy to pin down. As time passes, however, it often becomes clearer. Jeffers now sees

**RIGHT**
Cover, *Lost and Found*, 2005

He ran down to the harbour and asked a big ship to take them to the South Pole. But his voice was much too small to be heard over the ship's horn.

how these early book concepts (and, indeed, later ones, though very different in form) can be traced back to his unsegregated education, where he learned to see things from two sides, 'from here and there'. He and Rory were aware from an early age of being 'bilingual', as they called it, in that they could 'speak' both Catholic and Protestant:

**OPPOSITE**
Interior page, *Lost and Found*, 2005

**BELOW**
Vignette, *Lost and Found*, 2005

*I think we were kind of aware of that constantly. I could see the very visual, physical traits of Catholic culture, how different they were from the physical, visual aspects of Protestant culture. If you take the wall murals in Northern Ireland, for example – there's a whimsy to the Catholic, nationalist ones that played on history and folklore, and then there was the graphic, militant nature to the Unionist/ Protestant ones, and I always remember thinking at the time, 'I'm not supposed to think this but the Unionist ones look cooler' because there was a graphic quality to them and I liked the colours better. And I think both of those qualities/cultures (Catholic and Protestant) have played into the visual aspects of my work. But I do think it's that ability to think about things and explain things and understand that people are different – different realities and different truths, to some degree, and the importance of storytelling.*

Notwithstanding the immediate success of the early picturebooks, Jeffers needed to continue to take on general illustration commissions in order to get by, while also continuing to paint. For most illustrator–authors, picturebooks rarely sell in sufficient quantities to provide a full-time living. If several books remain in print and keep selling, the royalties accumulate. Those early years involved a lot of juggling, but crucially Jeffers was managing to survive on projects that involved some form of image-making, without having to take on other types of work.

**Breaking out: the first ten years**

Never one to stand still creatively, after *Lost and Found* – the second story to feature the 'boy' – Jeffers was aware of the dangers of becoming typecast, in terms of both concept and the 'whimsical' watercolour technique, if he were to go straight into a third in the series. At the time, he was working on numerous other personal projects and ideas, and he felt that he had to break out, at least temporarily, if he were to have any chance of becoming a multifaceted creative practitioner in the visual arts. Publishers are invariably under great pressure to capitalize on successes, and at first HarperCollins had concerns about him releasing an entirely different type of book. However, a friendly agreement was reached, along the lines of: 'OK, get it out of your system, but then we want you to do the book *we* want next.'

*The Incredible Book Eating Boy* (2006) was a major stylistic and conceptual departure from the two books that had launched Jeffers's career. Gone were the delicate watercolour washes. Instead, the visual vocabulary of the book was more closely aligned to preoccupations that were emerging in his paintings – a construction of letterforms, typewriter scripts, numbers, diagrams, exercise books and graph papers, integrated through controlled use of colour, collaged papers, distressed surfaces and paint. All of this combined to tell the story of Henry, a boy who loved books: 'But not like you and I love books, no.' It was, of course, a huge success, in both sales and critical acclaim. Jeffers had earned the right to be trusted to follow his creative instincts.

**BELOW**
Vignette, *Lost and Found*, 2005

**OPPOSITE**
Front cover, *The Incredible Book Eating Boy*, 2006

**OVERLEAF**
Original artwork, *The Incredible Book Eating Boy*, 2006

**PAGES 36–37**
Interior illustrations, *The Incredible Book Eating Boy*, 2006

**OLIVER JEFFERS PRESENTS**

# THE INCREDIBLE BOOK EATING BOY

bite     chew     chew

chew     gulp     green

greener     greenest     BOKE*

*An IRISH word for ejecting the contents of your stomach

OLIVER JEFFERS

Encouraged by the success of *The Incredible Book Eating Boy*, and the creative freedom it had brought him, Jeffers turned his attention to new projects. While honouring his promise to produce a third book in the 'boy' series, in the form of *The Way Back Home* (2007), he was also hatching the idea for his next freestanding picturebook concept, *The Great Paper Caper*, which would be published the following year. By now, Jeffers was living in New York, finally fulfilling a dream that he had harboured since attending summer camp at Camp Dudley as a child. *The Way Back Home* can

**ABOVE**
Vignettes, *The Way Back Home*, 2007

**ABOVE**
Cover, *The Great Paper Caper*, 2008

**OVERLEAF**
Original artwork, *The Great Paper Caper*, 2008

**PAGES 42–43**
Original artwork with background tint, *The Great Paper Caper*, 2008

clearly be seen to incorporate a sense of 'looking back' from afar, both literally and philosophically – of being in one place and thinking of another, dualities that have gone on to be present across much of his work. The book also reflects his growing visual preoccupations with space, distance, water and scale, as backdrops to conceptual explorations of problem-solving, conciliation and friendships between different worlds. The 'simultaneous duality' of being poised between two worlds is something that Jeffers has attributed to his Belfast upbringing, his schooling and the parallel narratives or 'truths' of Catholic and Protestant cultures.

*The Great Paper Caper* was a concept that gave Jeffers an opportunity to experiment with the kind of narrative structure and form that is particular to the picturebook. The story of a bear who is secretly cutting down trees in order to produce enough paper to fuel his paper aeroplane obsession is unusual enough in itself. But the brilliance of the book lies in its use of word–image counterpoint, visually revealing the culprit to the audience at the start, in conscious 'Lieutenant Columbo' style, while the characters seeking to track down

40

the 112th BIENNIAL Paper Airplane COMPETITION

NEXT SATURDAY - 2pm
all entries welcome

42

OLIVER JEFFERS

the criminal are carefully positioned so that they cannot see what we, the readers, see. As ever, the book concludes with conciliation, harmony, forgiveness, cooperation and kindness.

In 2010, Jeffers published *Up and Down*, the fourth in the 'boy' series, and *The Heart and the Bottle*, a highly emotive exploration of grief and loss. In *Up and Down*, the boy and the penguin go their separate ways as the penguin seeks to pursue his burning ambition to fly, only to find himself in peril. The two are reunited when the boy, who has been hunting for his friend, turns up just in time to break his fall, literally and metaphorically. In contrast to the whimsical watercolour technique of the series, in *The Heart and the Bottle* Jeffers once again seized the opportunity to experiment, importing photographic textures, including four-colour lithographic screen-dots, comfortably assimilating them with the more familiar watercolour and coloured pencils, alongside schematic, pictorial thought bubbles, to describe a girl's journey of emotional repair.

**ABOVE**
Vignette, *The Great Paper Caper*, 2008

**OPPOSITE AND PAGES 46–47**
Original artwork, *Up and Down*, 2010

OLIVER JEFFERS

This was a time when the children's publishing industry was becoming increasingly concerned that digital publishing might drive the physical picturebook to extinction – made all the more pressing with the launch of a new iPad app at the end of 2010. *The Heart and the Bottle* was released in app form and was one of the more successful translations into digital media. 'I had previously stayed away from apps as they just showed off what the technology could do rather than expanding the feeling of the story,' Jeffers explains. 'For this app, you could add things when the girl's curiosity was flourishing, and only take things away after she'd suffered heartache.' However, it soon became apparent that a book is a book, and a game is a game. In contrast to its noisy arrival, the picturebook app as a whole slipped away quietly.

Demonstrating Jeffers's extraordinary versatility, *Stuck* (2011) was the follow-up. Here he entered the world of

**BELOW**

Cover, *The Heart and the Bottle*, 2010

**OPPOSITE**

Original artwork, *The Heart and the Bottle*, 2010

OLIVER JEFFERS

The HEART and the BOTTLE
PAGE

7th MARCH 2009

the HEART AND THE BOTTLE
PAGE 15

**OPPOSITE**
Original artwork, *The Heart and the Bottle*, 2010

**BELOW LEFT**
Cover, *Stuck*, 2011

**BELOW RIGHT AND PAGES 52–53**
Interior pages, *Stuck*, 2011

slapstick, with a joyful, laugh-out-loud comedic venture. In its cumulative absurdity the book bears similarities to a nonsense rhyme in the manner of the 1950s song 'I Know an Old Lady Who Swallowed a Fly' by Rose Bonne and Alan Mills. As the reader turns the pages, anticipating what will happen next, various little (and big) surprises are thrown in. It is a masterpiece of the genre. The humorous vein continued with *This Moose Belongs to Me* the following year. The story of a boy and his unownable 'pet moose' is ostensibly once again a comedy of the absurd, but the inspiration for the book has serious roots. Now a New Yorker, Jeffers had been reading about how the Dutch had bought Manhattan from the Native Americans who lived there, and how very different ideologies around the concept of ownership existed within the two cultures. Jeffers had also recently had his first encounter with a real moose, while visiting a friend in Maine. As it ambled through the friend's back yard, he was astonished by the sheer size of the creature and made a drawing in his sketchbook of a person

and they
# ALL GOT STUCK

OLIVER JEFFERS

standing underneath one, adding some scribbled words about the moose being a useful pet for providing shelter from the rain. His editor at HarperCollins happened to see the drawing and suggested he try to develop it further. The moose, of course, could also be seen to represent our misguided desires to 'own' the natural world.

Over the next couple of years, Jeffers created a series of four picturebooks featuring the Hueys: *The New Jumper* (2012), *It Wasn't Me* (2013), *None the Number* (2014) and *What's the Opposite?* (2015). The name 'Hueys' came from Jeffers's grandfather, who had used it for all of his twenty-four grandchildren and great-grandchildren when unable to remember their names. With the exception of a handful of named characters, the Hueys are a largely indistinguishable group of indefinite number, drawn in a purposely minimal manner, with little in the way of individual characteristics to suggest age or gender. They represent human beings in general and form a canvas on which their creator explores philosophical questions about how we, as a species, relate to one another. The books cover themes such as individuality, anger, guilt, the concept of nothingness, and opposites. Inevitably the duality of different viewpoints, seeing things from different perspectives, once again comes to the fore, delivered with humour and empathy.

**ABOVE**
Vignette, *This Moose Belongs to Me*, 2012

**OPPOSITE**
Cover, *This Moose Belongs to Me*, 2012

# THIS MOOSE BELONGS TO ME

OLIVER JEFFERS

Rule 16: Knocking things down that were out of WILFRED's reach

good work!

**OPPOSITE**
Interior page, *This Moose Belongs to Me*, 2012

**BELOW**
Cover, *The Hueys in: What's the Opposite?*, 2015

The publication *Once Upon an Alphabet: Short Stories for All the Letters* (2014) came about at a time when Jeffers was still bound to the publisher's programming requirements, whereby if he didn't come up with a book by a particular date, someone else would fill the big booksellers' 'slot'. As always, he had sketchbooks of 'half-cooked ideas', but nothing fully formed, so he cleverly organized many of these mini-narratives into a substantial large-format 112-page hardback. It is a brilliantly anarchic take on the traditional A–Z book. In it, Jeffers deconstructs the genre and playfully explores a range of themes, from numbers and equations to scientific and philosophical perplexities, in a style reminiscent of Edward Lear's nonsense – intertwined here and there with ingenious connections and interactions between many of the four-page stories allocated to each letter. Everything is rounded off with delightful symmetry

as the vertigo-plagued astronaut of the first page finds a solution to his problem with a low-flying Zeppelin on the last. The existential threads that were becoming increasingly evident in Jeffers's work at this time, in both his books and his painting, are interwoven in entries such as 'M': 'Mary is made of matter.… In fact, matter makes up everything from magnets and maps to mountains and mattresses.' And here, the Moose puts in a guest appearance!

 A book such as this, with its complex yet playful interplay between the English language and pictorial narrative, would seem to be utterly untranslatable. Indeed, in a market in which publishers are heavily dependent on co-edition sales to make books viable, it is a powerful illustration of how Jeffers's status was able to bypass such concerns, with foreign-language publishers finding a variety of inventive ways of retaining the integrity of the book's original concept in translation. Of all Jeffers's works, this one in particular would seem to evidence his belief and frequent assertion

**BELOW**

Cover, *Once Upon an Alphabet*, 2014

**OPPOSITE AND PAGES 60–61**

Interior pages, *Once Upon an Alphabet*, 2014

that his books are generally accessible to all ages on different levels. He has never particularly liked the term 'children's picturebooks' and sums up his views with the observation, 'My picturebooks really can be read by anyone regardless of age. It just happens to be that a ton of 4-year-olds share my sense of humour.'

# T t

Not so long ago, and in a room not so far away, sat a typewriter and a terrified typist.

You see, whatever was written on this particular typewriter, however strange, had a terrible habit of coming true.

It was only a few moments before this typist...

# Q

The missing
Question

## Neither here nor there: artist as illustrator / illustrator as artist

'My picturebooks are about storytelling, and my art is generally about question-asking, though they are both about my trying to make sense of the world around me,' Jeffers responded when asked about these two aspects of his work in a 2015 interview for *Brooklyn Magazine*. The somewhat lazy idea that 'fine' or 'pure' artists are 'selling out' and risk tarnishing their careers if they engage with the so-called commercial or applied arts has remained stubbornly persistent in some quarters. Many of the great Renaissance masterpieces were commissioned to order by the wealthy nobility of the day, and there are examples throughout history of artists who were primarily known for their painting trying their hand at illustration and design (notably 20th-century British artists Paul Nash and John Piper, and American artist Ben Shahn). However, it is less common for artists to take the opposite route – to have a background in illustration and move into fine art – and historically, there was often a stigma attached to having worked as an illustrator. For Edward Hopper, his early years as a poster designer were something better not mentioned, and N. C. Wyeth felt that his legacy as a painter had been undermined by his success as a narrative illustrator. The notion that 'He who pays the piper calls the tune' runs deep.

    Jeffers encountered these prejudices in his early days as an artist and often distanced himself from the labels 'illustrator' and 'illustration', which he felt might hinder his efforts to establish himself in both worlds simultaneously. While the publishing world had no such qualms – indeed, versatility was seen as an asset – galleries were less open to an artist whose practice embraced illustration, a stance that Jeffers found somewhat belittling. At one stage, he considered adopting a pseudonym for his painting practice, although he swiftly changed his mind after discussing it with a friend. 'Don't do it,' his friend told him. 'Good work speaks for itself.' Despite attempts to keep the two practices separate at the beginning of his career, there was some overlap, as Jeffers explains: 'There were a lot of paintings I was making that were just interested in the night sky,

**RIGHT**
*Understanding Everything,*
oil on canvas, 2004

$$\frac{1}{8}\left(\frac{9}{\mu^2} - 1\right)^2$$

and in the visual language of the stars. And a lot of the landscapes I was painting were large empty landscapes... with rowing boats...the North Pole and South Pole, and that inevitably fed through into the "boy" books.'

Later, having met and married Suzanne, who is from an engineering background, he was inspired by their conversations about art and science, about the relationships between these two seemingly very different but equally fascinating ways of looking at and examining the world

through subjectivity and objectivity. He began to explore ways of bringing the visual vocabulary of mathematics into his figurative painting – an idea that appealed to the Belfast-based quantum physicist Dr Hugh Morrison, who bought one of the works, *Understanding Everything* (2004). In executing this painting, Jeffers had asked himself: 'How do I do this in the most rudimentary way?' Rather than including a random formula with no meaning, he decided that the source of light in the image could be the mathematical equation for the refraction of light. Morrison observed, 'Clearly you're making art about Bell's string theory' – to which the artist responded that he had no idea what he was talking about, but he would love to hear more. They went on to meet several times, eventually collaborating on a series of paintings called *Additional Information* (2006), into which Jeffers introduced equations that related to the science of searching for the fundamental building blocks of the universe, a unified theory of everything, or

**OPPOSITE**
*Protracted Landscape No. 6*, from the 'Measuring Land and Sea' series, Lazarides Gallery, London, 2015

**ABOVE**
*Dipped Painting No. 3*, from the 'Dipped Painting Project', 2014

'ultimate intelligence'. Here it is worth pointing out another crossover with Jeffers's picturebook-making: around the same time, he was working on *The Incredible Book Eating Boy*, whose central character is trying to be the smartest boy in the world.

The first gallery to accept Jeffers into its stable of artists was Lazarides Rathbone, now closed, in the heart of London's Fitzrovia. Specializing primarily in contemporary figurative and urban art, the gallery was introduced to Jeffers's work by the French photographer and street artist JR, after a chance meeting in New York. The gallery was, he says, taking a much-appreciated risk, and the exhibitions he staged there marked a turning point in his journey as a fine artist. In his 2015 exhibition 'Measuring Land and Sea' Jeffers once again explored relationships between art and science, this time through a series of land and seascapes that are peppered with the visual language of technical and numerical measurement, implying the futility and

pointlessness of our tendency to overcomplicate and expect to be able to quantify that which is unmeasurable.

Now based in Brooklyn, Jeffers undertook what became known as the 'Dipped Painting Project' (2014), a series that explores memory and loss through a combination of figurative painting, performance and installation. Framed portraits, which he had executed himself, were lowered into vats of enamel paint so that at least 50% of the image was obscured. Prior to dipping, the completed paintings were covered and not recorded photographically. An audience was invited to each performance, with the original painting existing only in the memory of these witnesses. The dipped paintings were then photographed in situ. The subjects of the original paintings were carefully chosen and interviewed at length about related personal experiences of memory.

The cross-fertilization that can be detected throughout Jeffers's work has become more marked in recent years. As his star has risen, extending his reach as an artist, the lines that once divided his painting and his picturebook-making have increasingly merged, not just for him but also for others working in the same fields. As Jeffers stated in his 2018 interview with Steven Heller, the motivations for all these works are similar, 'in so much as I am trying to satisfy my own sense of curiosity rather than make work with a particular audience in mind. This is as true of figurative oil painting as it is for picturebooks.'

## Collaborations

Illustration is often a solitary activity, pursued by freelancers working alone. In the traditional model, it involves an artist creating images to accompany – or augment the reader's experience of – a pre-existing text by a separate author. Nevertheless, notwithstanding the increasingly common phenomenon of the 'picturebook-maker', such as Jeffers, it is also a collaborative process of dialogue with editors, designers and printers. Although the picturebook-maker may have a strong sense of the overall arrangement of elements within a book, the designer's input often adds up to much more than mere aesthetics:

**OPPOSITE**
Dust-jacket design for *The Boy Who Swam with Piranhas* (David Almond), 2012

**PAGE 68**
Cover design for *The Boy in the Striped Pyjamas* (John Boyne), 2016

**PAGE 69**
Cover design for *The Terrible Thing That Happened to Barnaby Brocket* (John Boyne), 2013

From the Author of
THE BOY IN THE STRIPED PYJAMAS

# JOHN BOYNE

## THE TERRIBLE THING THAT HAPPENED TO BARNABY BROCKET

*illustrated by* OLIVER JEFFERS

it can play a significant role in the delivery and pace of the narrative or sequence. Jeffers's older brother Rory, for instance, has been a key collaborator throughout his career, in his role as graphic designer of many of the books.

    Oliver Jeffers's insatiable creative and intellectual curiosity has led him to take on a number of collaborative projects, not only in book publishing and fine art, but also a wide range of other fields. Examples include music (notably, when he worked with Bono to design stage projections for U2's 'Innocence + Experience' tour in 2015), science, film, typography and site-specific sculpture. Within publishing, the scope of his involvement has varied considerably. At one end of the spectrum are his occasional sorties into the traditional role of illustrator, providing the visual accompaniment to pre-existing texts. This is a role that he now only rarely takes on, and only if he feels particularly drawn to the material, as was the case with authors John

**OPPOSITE**

Cover design for *Noah Barleywater Runs Away* (John Boyne), 2010

**BELOW**

Interior spread, *A Child of Books* (Oliver Jeffers/Sam Winston), 2016

Boyne and David Almond. At the other end of the spectrum is a process of 'purer' collaboration, in which he co-creates a book 'from the bottom up'.

This latter approach is perhaps best exemplified by the two books so far produced in partnership with Sam Winston for Walker Books and its American arm, Candlewick Press: *A Child of Books* (2016) and *The Dictionary Story* (2024). Winston originally studied graphic design at Camberwell College of Arts, part of the University of the Arts, London. Growing up, he struggled with language, but he became increasingly fascinated by the visual form of the printed word. One of his tutors explained to him that the kind of work he was producing perhaps fell more naturally into the field of the artist's book rather than graphic design. He now creates small editions of books, along with book-related artefacts that can be seen as a form of sculpture.

Jeffers and Winston were introduced to each other by a mutual friend, London-based artists' agent Sam Summerskill. Summerskill had a feeling that the two of them 'would get along', and they did. Describing the first time they met, Jeffers recalls Winston saying 'Nice "old"

**BELOW**

Interior spread, *The Dictionary Story*, 2024

to meet you' as they parted, so tangible was the sense that they had known each other for years. It wasn't long before the inevitable 'We should do something together' came up in conversation. Winston, says Jeffers, is extremely disciplined and ensured that they set aside time to work on their first project, *A Child of Books*. He felt that it was especially important to meet in person to develop the idea. Progress was slow, as they developed ways to merge their visual languages stylistically, and the book had a lengthy gestation period of five years in total. They began by exploring their shared love of literature and looking at past work. The overall concept was one that Winston had originally toyed with but had taken in a different direction. Jeffers felt that it was worth revisiting, so together they rewrote and illustrated it. The boundaries between where one person's work ends and the other's begins are blurred, but Winston's so-called 'typographic landscapes' and Jeffers's more pictorial character renderings merge to form a truly collaborative fusion of word, image, word as image, and image as word. A joint project such as this, in which both parties are credited equally as bookmakers, is unusual in an industry that has traditionally sought a clear delineation of roles, often in the past commissioning an author and an illustrator separately.

Their follow-up collaboration, *The Dictionary Story*, took a full eight years to reach publication. Once again, it was rooted in an older idea that Winston had originally explored in a limited edition. Jeffers felt it was worth dusting off, but the question was whether it could be reworked into a book with broader appeal – or, in Winston's words, adapted to compete with 'mass-market books', as distinct from the rarefied world of the limited-edition artist's book. *The Dictionary Story*, in which a disgruntled dictionary decides to bring her words to life, subverts the traditional, functional role of the dictionary as a reference tool. As the words embrace their newfound freedom, chaos ensues. The complexity of the craft processes involved in the making of the book meant that the collaborative nature of *The Dictionary Story* extended beyond the co-authors. Artists who made important contributions are acknowledged in the opening pages, including South

# Imaginary FRED

EOIN COLFER
Oliver Jeffers

**OPPOSITE**
Cover design for *Imaginary Fred* (Eoin Colfer), 2015

**BELOW**
Vignettes, *Imaginary Fred* (Eoin Colfer), 2015

**OVERLEAF**
Interior spread, *Imaginary Fred* (Eoin Colfer), 2015

Korean designer bookbinder Haein Song and American photographer Yasmina Cowan.

Jeffers's partnership with Irish author Eoin Colfer evolved in a different way, perhaps a little more traditionally, yet equally innovative. They met at the Sydney Writers' Festival and informally discussed the possibility of working together. Soon after, Colfer got in touch with an idea that he had developed with Jeffers in mind. These were the beginnings of what would become *Imaginary Fred* (2015), who 'floated like a feather in the wind until a lonely little child wished for him'. Jeffers felt immediately that it would provide him with a new challenge and he was eager to be involved. In terms of format, this 48-page work falls somewhere between picturebook and illustrated book. There is more text than you would usually expect in a picturebook, yet it leaves plenty of room, literally and conceptually, for the images to play an equal role in the delivery of the humorous but poignant narrative. Colfer brilliantly tells the story from the perspective of the long-suffering

AREN'T they WONDERFUL?

when does it START?

When Duncan showed his teacher his new picture, she gave him an A for coloring...

imaginary friend, always destined to be discarded when a real friend arrives on the scene. The two bounced ideas off each other – with Colfer making some visual suggestions that Jeffers adopted, and Jeffers contributing to the ending – and the resulting marriage between word and image is exquisite. Jeffers's use of a green halftone to represent Fred, and the character's tendency to fade in and out of existence, is a stroke of graphic genius.

However, it is Jeffers's collaboration with the American author and filmmaker Drew Daywalt that has been perhaps the best known of the partnerships. The hugely successful picturebook *The Day the Crayons Quit* (2013) was, in fact, Jeffers's first-ever collaboration with another author. Several more 'crayons' books have followed, including *The Day the Crayons Came Home* (2015) and *The Crayons' Christmas* (2019), as well as a number of smaller spin-offs in the series.

Prior to working with Daywalt, Jeffers says that he had sworn never to collaborate with anyone on a picturebook, 'only because I thought of myself not as a "gun for hire", really, at that point. Also, with a picturebook, you're given a finished manuscript and there is normally no opportunity for the words to be informed by the images – it's done, it's dusted, it's a one-way street.' The genesis of this project was a serendipitous encounter at the office of Jeffers's American editor.

**ABOVE**
Interior spread, *The Day the Crayons Quit* (Drew Daywalt), 2013

**OPPOSITE**
Cover design for *The Day the Crayons Quit* (Drew Daywalt), 2013

OLIVER JEFFERS

# THE DAY the CRAYONS QUIT

by DREW DAYWALT

PICTURES by OLIVER JEFFERS

*From the illustrator of 'STUCK' and 'THIS MOOSE BELONGS TO ME'*

Dear Duncan,
I see Yellow crayon already talked to you, the BIG WHINER. Anyway, could you please tell Mr. Tattletale that he IS NOT the color of the sun? I would, but we're no longer speaking.
We both know I am clearly the color of the SUN because, on thursday, you used me to color the sun on BOTH the "monkey island" and the "meet the zookeeper" pages in your "DAY AT the ZOO" coloring book. orange you glad I'm here? Ha!
your pal (and the real color of the sun)

orange crayon

Meet the Zookeeper

Monkey Island

To: DUNCAN

**BELOW AND OPPOSITE**

Vignettes, *The Day the Crayons Quit* (Drew Daywalt), 2013

The editor had to leave the office briefly to take an important phone call and, while making his apologies, he joked, 'Don't look at anything on my desk!' Lying face-up in front of Jeffers was Daywalt's manuscript for *The Day the Crayons Quit*. Needless to say, Jeffers couldn't resist thumbing through and found himself thoroughly fascinated and drawn into how it could be visualized. When the editor returned, Jeffers asked who was going to illustrate it, thinking that on learning the name of the chosen illustrator, he would then follow up with, 'Well, tell them not to mess it up. It's a great concept.' But the answer headed him off: 'No one yet – are you interested?' Jeffers realized immediately that he had been tricked, but the temptation was too great:

> *Immediately I could see a way around my self-imposed set of rules, because the entirety of that book is visual. This is not a script informing the pictures; these are photographs of letters so there's no way that the pictures could inform the words – it's a concrete column, an immovable object. And the rigidity of that structure I actually found quite enticing. So that's how that came about, and then it opened up that threshold a little.*

And so began a highly successful marriage.

Reflecting on his collaborative work as a whole, and the suggestion that he has helped to break down perceived boundaries between author and illustrator, Jeffers says:

> *Well, we didn't set out to do that. I've collaborated a lot, with artists as well as in picturebook work. You can get together and make something together, and there have been a couple of great examples of that. But also, some less great experiences. In the art world there's a lot more room for experimentation, but also a lot more room for volatility. But there's a lot less risk in terms of what the end result will be. Overall, I've learned that real collaboration means a mutual respect for each other, as human beings and as practising creatives, in whatever discipline. And crucially, mutual agreement that the project comes first. It doesn't matter who comes up with the idea, as long as the idea is better for the collaboration. And then it doesn't matter. You have to place ego to one side. And ultimately, you create something that neither of you could have made alone.*

## A bigger picture: the existential picturebook

After the publication of *Once Upon an Alphabet* in 2014, there was a significant shift in the nature and direction of Jeffers's bookmaking. Although *Once Upon an Alphabet* was, on the surface, full of playful, delightful wordplay and nonsense, it contained many oblique references to the folly of humankind and the wider issues we face. The year 2015 also heralded a new phase of life for the Jeffers household in the form of parenthood, with the arrival of Harland Jeffers. Three years later, Harland was joined by a baby sister, Mari. Thoughts that had already been quietly incubating, about how we as a species live and think, were now crystallizing into ideas for a series of picturebooks that would become increasingly ambitious in their scope, culminating in the 2023 publication *Begin Again: How We Got Here and Where We Might Go – Our Human Story. So Far*. In this 112-page tour de force of illustration, design and production, Jeffers implicitly asks the question: 'How do we make the world a better place?' In a reflective essay at the end of the book, he muses, 'Over the last few years, I've started to wonder if my role in life is to ask the "foolish" questions loudly and fearlessly enough that we might clarify assumptions for the benefit of everyone. To attempt to distil things down to a simple enough point, where they can be accessed, and be agreed upon, by anyone.'

Jeffers was further influenced by reading about astronauts who had spent long periods on a space station, and how their perceptions of territory and boundaries, and their sense of 'home' had so often been redefined by seeing our planet from afar, as a single entity. He first explored these thoughts in picturebook form in *Here We Are: Notes for Living on Planet Earth* (2017). The book is a manual of sorts for a newborn child, with Jeffers explaining the world as simply as possible and reducing the complexities of life on earth to a series of essential notes. The illustrations, however, are lavishly executed and richly detailed, to fully express the sheer wonder and breadth of life on Planet Earth.

By contrast, *The Fate of Fausto: A Painted Fable*, which followed in 2019, makes use of wide expanses of white

**ABOVE**
Cover, *Here We Are: Notes for Living on Planet Earth*, 2017

**ABOVE**

Interior spreads, *Here We Are: Notes for Living on Planet Earth*, 2017

# THE FATE of FAUSTO

A PAINTED FABLE
BY OLIVER JEFFERS

**OPPOSITE**
Cover, *The Fate of Fausto: A Painted Fable*, 2019

**BELOW**
Interior spread, *The Fate of Fausto: A Painted Fable*, 2019

**OVERLEAF**
Original artwork, *The Fate of Fausto: A Painted Fable*, 2019

space and minimal, almost monotone wording, to retell the classic German cautionary tale of greed and arrogance. The illustrations for this modern take on an old fable were created using a limited palette, executed through the process of stone lithography at the prestigious Idem Editions studio in Paris to lend the book a traditional feel. Designer David Pearson was enlisted to establish a classic early/mid-century story-book aesthetic, typesetting the book by hand. Pearson selected a font designed by Roger Excoffon in 1945, Chambord Maigre, which was chosen for its simple appearance but also for its connection to France, where the illustrations were created. The idea for this book had emerged several years previously, but the arrival of young Harland had convinced Jeffers to hold it back and create a book with a more celebratory, positive message: *Here We Are*. In 2020, *What We'll Build: Plans for Our Together Future* was published, a touching story of a father and daughter as they set about laying the foundations for their life together.

There was once a man who believed he owned everything and set out to survey what was his.

OLIVER JEFFERS

# WHAT WE'LL BUILD

PLANS FOR OUR TOGETHER FUTURE

OLIVER JEFFERS

**OPPOSITE**
Cover, *What We'll Build: Plans for Our Together Future*, 2020

**ABOVE**
Original artwork, *What We'll Build: Plans for Our Together Future*, 2020

**OVERLEAF**
Original artwork, *What We'll Build: Plans for Our Together Future*, 2020

Although clearly inspired by parenthood, it echoes the pared-down approach to traditional rhythmic picturebook storytelling explored in *The Fate of Fausto*, with its strong message of building a better future, not just for ourselves but for everyone.

Light relief in the form of *There's a Ghost in this House* appeared in 2021. While playful in terms of subject matter, *There's a Ghost in this House* is a complex exploration of the relationship between the physical book and its narrative content. The images combine vintage black-and-white photographs of domestic interiors with hand-drawn

OLIVER JEFFERS

**OPPOSITE**
Interior page, with transparent overlay revealing the ghosts, *There's a Ghost in this House*, 2021

**ABOVE LEFT**
Cover, *There's a Ghost in this House*, 2021

**ABOVE RIGHT**
Publicity shot for *There's a Ghost in this House*, 2021

illustrations of a girl, but the narrative depends on a series of transparent pages interleaved between the regular pages. Most spreads feature the girl as she looks for ghosts, on the left-hand page, the text on the right-hand page, and a transparent page in between. As the reader turns the pages, the transparent paper reveals mischievous ghosts running amok around the house, printed on the vellum and positioned perfectly within the composition. It is a classic example of the picturebook's potential as theatre. The exhibition 'A Fraid of Ghosts' (Bryce Wolkowitz Gallery, New York), which was drawn from the experimentation of making the book and was staged to coincide with its release, developed this idea further. Offering an immersive gallery experience, it brought together Jeffers's opposing worlds of publishing and fine art in a body of work that he describes as his most poignant to date.

In *Meanwhile Back on Earth: Finding Our Place Through Time and Space* (2022), Jeffers takes on the challenge of expressing how small the earth is, both literally and in terms of our human preoccupations, in relation to the

96

vastness of the universe. Taking a little family on a drive out to the edge of our solar system in their car, he explores time and space by using the number of years it would take us physically to travel to our nearest planetary neighbours to highlight conflicts in our human past.

The site-specific installation project *Our Place in Space* took these ongoing concerns with explaining the greater context of our existence one step further. Designed by Jeffers in collaboration with astrophysicist Professor Stephen Smartt, together with a creative team led by Nerve Centre, *Our Place in Space* is a scale model of our solar system. In some cases stretching across 10 kilometres, the large-scale fibreglass sculptures that make up the trail – although scaled down (by 591 million to 1) – give a sense of the distance between the planets in our solar system, and by suggestion the pointlessness of our incessant territorial

**OPPOSITE**
Travelling installation, *Our Place in Space*, 2022–23

**ABOVE**
Cover, *Meanwhile Back on Earth: Finding Our Place Through Time and Space*, 2022

**ABOVE AND OVERLEAF**

Interior spreads, *Meanwhile Back on Earth*, 2022

ver a period of a year, from April 2022 to
 er 2023, the trail travelled from Derry–Londonderry
  ast, Cambridge, Liverpool, the North Down coastal
   n and Hanoi.

In *Begin Again: How We Got Here and Where We Might Go – Our Human Story. So Far* (2023), those 'foolish' questions about our existence on Planet Earth, past, present and future, are indeed asked 'loudly and fearlessly', in the process breaking most of the rules of commercial picturebook publishing. It reads almost as a stream of visual and verbal consciousness, a meditation on where we come from and where we are going, and how we, humanity, might create a better story for our shared home. While it is officially labelled as suitable for age seven upwards, it defies easy categorization. It is a book that distils so many

**BELOW**
Interior spread, *Begin Again: How We Got Here and Where We Might Go – Our Human Story. So Far*, 2023

**OPPOSITE, ABOVE LEFT**
Vignette, *Begin Again*, 2023

**OPPOSITE, ABOVE RIGHT**
Cover, *Begin Again*, 2023

**OLIVER JEFFERS**

**BEGIN AGAIN**

HOW WE GOT HERE AND WHERE WE MIGHT GO — OUR HUMAN STORY. SO FAR.

ON WHICH WE HAVE NOW DRAWN IMAGINARY LINES SO WE KNOW

WHO WE ARE AND WHO WE ARE NOT

US  THEM

WHERE WE BELONG AND WHERE WE DO NOT

of the themes and preoccupations that have been emerging in Jeffers's work over the past two decades or so: space, distance, scale, duality; looking from here to there, from there to here; from outer space to earth, from Brooklyn to Belfast; mine or yours, me or we. It is a book for all and a book for our times.

## The future

Looking back at the later books, Jeffers describes them as 'sort of philosophical forays into the state of the world in a palatable form, culminating in *Begin Again*'. Indeed, in the early stages of these 'forays', he found himself thinking, 'I don't know if I'm ever going to make another "classic picturebook" again.' Since *Begin Again*, however, he has felt a burning need to do just that: to get back to the joy of pure storytelling, without trying to change the nature of public discourse. 'I've learned to "never say never", so I think I'll always make classic picturebooks because of this simple joy,' he says. Indeed, as this book goes to press, Jeffers is preparing to release a fifth title in the 'boy' series, *Where to Hide a Star*, twenty years after the publication of the original. He has also written and art-directed a book that Kevin Waldron will illustrate, which comes out in autumn 2025.

Now living back in Belfast, having returned with his family to be close to his father, Jeffers sees it as part of his role as an artist to get people to question how they feel, with bookmaking forming one string to that bow: 'You see that with *Here We Are*, you see it with *The Fate of Fausto* to a degree. You certainly see it with *Meanwhile Back on Earth* and *Begin Again*. But those have started to manifest into different experiences, like the giant sculpture trail, *Our Place in Space*.' He is interested in taking the ideas and observations in *Begin Again* and exploring the potential through different media – for example, theatre, film, live drawing and lectures – rather than trying to put them into another book: 'As with all of these project ideas, I can sense there is something "behind the veil of mist", but you've just got to force the time to work your way through that and see

**ABOVE**
Original artwork for the cover of *Where to Hide a Star*, 2024

what's in there. So, I don't necessarily know what the next thing is going to be, but I do know that I will always have a need to make books.'

The prodigious volume of creative work that has flowed from the studio of Dr Oliver Jeffers MBE would, for most artists, constitute a lifetime of achievement. In reminding ourselves that this has happened in little more than two decades since his student graduation exhibition, we can only wonder at what is yet to come. It seems remarkable that he may only be in the early stages of his career.

Those all-important sketchbooks are still being filled with 'half-cooked' ideas, which may or may not evolve into fully formed projects. This book began with a quote: 'We are a story-driven species.' Oliver Jeffers is passionate about helping us to change that story.

# CHRONOLOGY

1977 Oliver Jeffers born 5 October, Port Hedland, Western Australia

1978 The family move back to Belfast after Oliver's mother, Marie, begins to show early signs of what would later be diagnosed as multiple sclerosis

1982–88 Attends Saint Thérèse of Lisieux Primary School in Belfast

1988–97 Attends Hazelwood Integrated College, Belfast

1990 Gains a scholarship to attend Camp Dudley, Westport, New York, along with brother Rory. Goes to Camp Dudley twice, in successive years, where he meets future collaborator Mac Premo.

1994 Filmed along with Hazelwood classmates in fly-on-the-wall documentary *Belfast Lessons: Inside the Peace Process*, a co-production by Channel 4 and the French company Point du Jour

1997 Enrols at the Belfast School of Art, part of Ulster University

1999 Takes a year out of university to travel through the USA and Australia. First solo exhibition, 'Opposites', is held at Manly Gallery, Sydney.

2000 Marie dies in November

2001 Graduates from Ulster University with a first-class honours degree

2004 First book, *How to Catch a Star*, is published. An exhibition of the original art is held at Ormeau Baths Gallery, Belfast.

2005 Publication of *Lost and Found*. Awarded Merit at the Bisto Book of the Year Awards for *How to Catch a Star* and Gold at the Nestlé Smarties Book Prize (5 years and under category) for *Lost and Found*.

2006 Releases *The Incredible Book Eating Boy*, a stylistic and conceptual departure from the first two books. Collaborates with quantum physicist Dr Hugh Morrison on a series of paintings, *Additional Information*. Wins the Blue Peter Book Award and Merit at the Bisto Book of the Year Awards for *Lost and Found*, and the Channel 4 Richard & Judy Award for *The Incredible Book Eating Boy*.

2007 Appointed as official illustrator for World Book Day. Wins Children's Book of the Year (Junior) at the Irish Book Awards and Merit at the Bisto Book of the Year Awards for *The Incredible Book Eating Boy*. Moves to New York in November.

2008 *Lost and Found* is made into an animation by London-based Studio AKA, premiering in the UK on Christmas Eve (Channel 4). Takes part in the group show 'BP National Portrait Awards', National Portrait Gallery, London. Wins Merit at the Bisto Book of the Year Awards for *The Way Back Home*.

2009 Wins Merit at the Bisto Book of the Year Awards for *The Great Paper Caper*. Film adaptation of *Lost and Found* is awarded a BAFTA for best children's animation.

2010 Marries Suzanne. Moves to Brooklyn. *The Heart and the Bottle* is released as an iPad app by HarperCollins. Awarded two New York Emmy Awards ('Commercial – Single Spot' and 'Graphics') for *Artwalk '09*, a collaboration with Mac Premo.

2011 Wins the V&A Book Illustration Award for *The Heart and the Bottle*

2012 Takes part in community-curated open studio initiative 'GO Brooklyn', Brooklyn Museum, Brooklyn, New York; the first dipped painting is displayed, although it is not included in the 'Dipped Painting Project' because it does not involve a performance – the performance concept comes from a series of accidental occurrences at this painting's creation. Solo show 'Here or There' held at Gestalten Space, Berlin. Receives the Honour Award for Illustration at the CBI Book of the Year Awards (formerly the Bisto Book of the Year Awards) for *Stuck*. Winner of the Children's Book of the Year (Junior) at the Irish Book Awards for *This Moose Belongs to Me* and the New York Times Best Illustrated Children's Books for *The Hueys in: The New Sweater*.

2013 Illustrates *The Day the Crayons Quit* (written by Drew Daywalt). 'Nothing to See Here', solo show at Lazarides Rathbone, London, the first gallery to represent him. Illustrates the vinyl cover for U2's *Ordinary Love* and co-directs the video with Mac Premo. Receives the Orbil Best Illustrated Book Award for *Stuck* and the Honour Award for Illustration at the CBI Book of the Year Awards for *This Moose Belongs to Me*.

2014 Solo show 'How to Catch a Star Original Art', at the Southbank Centre, London, marks ten years since the publication of his debut book. Begins the first in a series of *Dipped Painting* performances, 'dipping' nos 1–6 at Sub Rosa, in the basement of an old warehouse building, New York. Receives the Hay Festival of Literature and the Arts Inaugural Hay Medal for an Outstanding Body of Work. *The Day the Crayons Quit* wins the Children's Choice Award at the CBI Book of the Year Awards.

2015 Son Harland Jeffers is born. Holds his second solo show, 'Measuring Land and Sea', at Lazarides Rathbone, London. Contributes designs for video content for U2's 'Innocence + Experience' tour. Wins the Texas Bluebonnet Award for *The Day the Crayons Quit* (illustrator) and two CBI Book of the Year Awards for *Once Upon an Alphabet*.

2017 *Here We Are: Notes for Living on Planet Earth* is published, marking a significant shift in direction. Receives the Professional Achievement Award from the British Council as part of its Alumni Awards. Wins (with Sam Winston) the Bologna Ragazzi Award in Fiction at the Bologna Children's Book Fair for *A Child of Books* and the Prix des libraires du Québec (international youth category) for the cover illustration of *The Boy Who Swam with Piranhas* (written by David Almond). *Kickable*, a participatory installation developed with Mac Premo, is shown at an open studios event at the Invisible Dog Art Center, Brooklyn, New York.

2018 Daughter Mari Jeffers is born. *The Working Mind & Drawing Hand of Oliver Jeffers: For All We Know* is published by Rizzoli.

2019 Holds his first solo show in New York, 'For All We Know', at Bryce Wolkowitz Gallery. First retrospective '42 Observations on Modern Life', at Lazinc, Sackville Street, London, showcasing his exploration of sculpture, painting, found images and collage over a ten-year period. *The Moon, the Earth and Us*, his first public sculpture, is displayed on the High Line, New York.

2020 Returns to Belfast in March. Delivers TED Talk, 'Ode to Living on Earth', released on Earth Day. *Here We Are: Notes for Living on Planet Earth* is adapted as an animated short film for Apple TV+ to mark Earth Day.

2021 Immersive solo show 'A Fraid of Ghosts', Bryce Wolkowitz Gallery, New York. *Here We Are: Notes for Living on Planet Earth* wins an Emmy for Outstanding Special Class Daytime Animated Program.

2022 Awarded an MBE for services to the arts. First solo show in Boston, 'The Night in Bloom', Praise Shadows Art Gallery, Brookline, Massachusetts.

2022–23 *Our Place in Space* sculpture trail installed in Derry–Londonderry, Belfast, Cambridge, Liverpool, North Down and Hanoi, Vietnam.

2024 Awarded an honorary doctorate from Ulster University. Stages 'Seen', an outdoor exhibition of portraits of young asylum seekers, in Thanksgiving Square, Belfast. *Where to Hide a Star*, the latest in the series featuring the 'boy', is published twenty years after the first book.

## SELECT BIBLIOGRAPHY

**Books written and illustrated by Oliver Jeffers**

*How to Catch a Star*, HarperCollins, 2004
*Lost and Found*, HarperCollins, 2005
*The Incredible Book Eating Boy*, HarperCollins, 2006
*The Way Back Home*, HarperCollins, 2007
*The Great Paper Caper*, HarperCollins, 2008
*The Heart and the Bottle*, HarperCollins, 2010
*Up and Down*, HarperCollins, 2010
*Stuck*, HarperCollins, 2011
*This Moose Belongs to Me*, HarperCollins, 2012
*The Hueys in: The New Jumper*, HarperCollins, 2012
*The Hueys in: It Wasn't Me*, HarperCollins, 2013
*The Hueys in: None the Number: A Counting Adventure*, HarperCollins, 2014
*Once Upon an Alphabet: Short Stories for All the Letters*, HarperCollins, 2014
*The Hueys in: What's the Opposite?*, HarperCollins, 2015
*Here We Are: Notes for Living on Planet Earth*, HarperCollins, 2017
*The Fate of Fausto: A Painted Fable*, HarperCollins, 2019
*What We'll Build: Plans for Our Together Future*, HarperCollins, 2020
*There's a Ghost in this House*, HarperCollins, 2021
*Meanwhile Back on Earth: Finding Our Place Through Time and Space*, HarperCollins, 2022
*Begin Again: How We Got Here and Where We Might Go – Our Human Story. So Far*, HarperCollins, 2023
*Where to Hide a Star*, HarperCollins, 2024

**Books produced collaboratively**

*A Child of Books*, Oliver Jeffers and Sam Winston, Walker Books, 2016
*The Dictionary Story*, Sam Winston and Oliver Jeffers, Walker Books, 2024

**Books illustrated by Oliver Jeffers**

*Noah Barleywater Runs Away*, John Boyne, Yearling (Random House), 2010
*The Boy Who Swam with Piranhas*, David Almond, Walker Books, 2012
*The Terrible Thing That Happened to Barnaby Brocket*, John Boyne, Corgi, 2013
*The Day the Crayons Quit*, Drew Daywalt, HarperCollins, 2013
*Stay Where You Are and Then Leave*, John Boyne, Holt, 2014
*Imaginary Fred*, Eoin Colfer, HarperCollins, 2015
*The Day the Crayons Came Home*, Drew Daywalt, HarperCollins, 2015
*The Boy in the Striped Pyjamas*, John Boyne, Doubleday, 2016
*The Crayons' Christmas*, Drew Daywalt, HarperCollins, 2019

**Books as cover artist**

*The Weight of Water*, Sarah Crossan, Bloomsbury, 2012
*Five Go to Smuggler's Top*, Enid Blyton (*Famous Five* 70th anniversary edition), Hodder, 2012
*Illustrators' Sketchbooks*, Martin Salisbury, Thames & Hudson, 2023

**Other books**

*Neither Here Nor There: A Monograph of Paintings by Oliver Jeffers*, Gestalten, 2012
*The Working Mind & Drawing Hand of Oliver Jeffers: For All We Know*, Oliver Jeffers and various contributors, Rizzoli, 2018

**Sources of quotations**

Unless otherwise indicated in the text, all quotations are taken from transcripts of conversations between the author and Oliver Jeffers in April and May 2024.

ACKNOWLEDGMENTS

Firstly, a huge debt of gratitude is owed to Oliver Jeffers for finding the time in his busy schedule to speak with me at length about his life and work. Also, to everyone at Oliver Jeffers Studio, especially Philippa Jordan and Rory Jeffers for their ongoing assistance and encouragement. Thanks, too, to everyone at Thames & Hudson, especially my editor, Rebecca Pearson, and Editorial Director Roger Thorp. And finally, thanks to Series Editor Claudia Zeff and Series Consultant Sir Quentin Blake for their tireless work in promoting the world of illustration through this series.

CONTRIBUTORS

**Martin Salisbury** is Professor of Illustration at Cambridge School of Art in Anglia Ruskin University, where he designed, and for many years led, the MA Children's Book Illustration programme. After studying at art school in the late 1970s, he worked for many years as an illustrator, painter and part-time teacher. He has written a number of books on the practice and theory of illustration, including *Children's Picturebooks: The Art of Visual Storytelling* (with Morag Styles), *The Illustrated Dust Jacket: 1920–1970* and *Drawing for Illustration*. He lectures on illustration around the world and has acted as chair of the international jury at the Bologna Children's Book Fair.

**Quentin Blake** is one of Britain's most distinguished illustrators. For twenty years he taught at the Royal College of Art, where he was head of the illustration department from 1978 to 1986. Blake received a knighthood in 2013 for his services to illustration and in 2014 was admitted to the Légion d'honneur in France.

**Claudia Zeff** is an art director who has commissioned illustration for book jackets, magazines and children's books over a number of years. She helped set up the House of Illustration with Quentin Blake, now the Quentin Blake Centre for Illustration, where she is Deputy Chair. Since 2011 she has worked as Creative Consultant to Quentin Blake.

# INDEX

Page numbers in *italics* refer to illustrations

Additional Information  64
Almond, David  71
apps  48
art schools, history in Great Britain  18
*Asterix* (Goscinny & Uderzo)  12
Australia  12, 18

*The Bad-tempered Ladybird* (Carle)  13
*Begin Again: How We Got Here and Where We Might Go – Our Human Story. So Far*
   cover  *103*
   interior spreads  *102–3*
   themes  83, 102, 104
   vignettes  *103*
Belfast  *6–7*, 9, 16–17, 104
*Belfast Lessons: Inside the Peace Process* (documentary)  16
Belfast School of Art  17, 18
Bonne, Rose  51
Bono  70
*The Boy in the Striped Pyjamas* (Boyne)  68
*The Boy Who Swam with Piranhas* (Almond)  67
Boyne, John  70–71
*Brooklyn Magazine*  62
Bryce Wolkowitz Gallery, New York  95

Camp Dudley, Westport, New York  14
Candlewick Press  71
Carle, Eric  13
Channel 4  16
*A Child of Books* (Jeffers & Winston)  71, 73
climate change conferences  6
Colfer, Eoin  75, 78
collaborations  66–82
COP26  6
Cowan, Yasmina  75
*The Crayons' Christmas* (Daywalt)  78

*The Day the Crayons Came Home* (Daywalt)  78
*The Day the Crayons Quit* (Daywalt)  78, *79–80*, 81–82
Daywalt, Drew  78
*The Dictionary Story* (Jeffers & Winston)  71, *72*, 73–75
'Dipped Painting Project'  *65*, 66

Excoffon, Roger  87
exhibitions  65, 95

*The Fate of Fausto*
   artwork  2, 83, 87, *88–89*
   cover  *86*
   interior spreads  *87*
   themes  87, 104
football  13
'A Fraid of Ghosts' exhibition  95

Good Friday Agreement  16
Goscinny, René  13
*The Great Paper Caper*  38, *39*, *40–44*

HarperCollins  25, 54
Hazelwood Integrated College  15–16
*The Heart and the Bottle*  44, 48, *49–50*
Heller, Steven  16, 66
*Here We Are: Notes for Living on Planet Earth*  83, *84–86*, 104
Hopper, Edward  62
*How to Catch a Star*
   artwork  *26–27*, 28
   cover  *22*
   dummy copies  24
   publication  6, 25
   student work  *4*, *19–20*, *22*, *23*
   vignettes  *24–25*
Hueys  54, *57*

Idem Editions  87
'I Know an Old Lady Who Swallowed a Fly' (song, Bonne & Mills)  51
*Imaginary Fred* (Colfer)  74, 75, *76–77*, 78
*The Incredible Book Eating Boy*  32, *33–37*, 38, 65
*It Wasn't Me*  54

Jeffers, Harland (son)  83, 87
Jeffers, Mari (daughter)  83
Jeffers, Marie (mother)  12, *13*, 21
Jeffers, Oliver
   art school  18–23
   birth  12
   childhood and education  12–17
   grandfather  54
   images of  2, *13–15*, *23*
   meets and marries Suzanne  16, 63
Jeffers, Paul (father)  12, *13*, 15, 17
Jeffers, Rory (brother)  12, *13–14*, 30, 70
Jeffers, Suzanne (wife)  16, 63
JR  65

landscapes  62–63
Lazarides Rathbone gallery, London  65
*Lost and Found*  28, *29–32*

mathematics  64
*Meanwhile Back on Earth: Finding Our Place Through Time and Space*  95, 97, *98–101*, 104, *112*

'Measuring Land and Sea' series  64, 65–66
Mills, Alan  51
Morrison, Hugh  64
murals  *6–7*, 31

Nerve Centre  97
*The New Jumper*  54
New York  14, 38, 51
*Noah Barleywater Runs Away* (Boyne)  70
*None the Number*  54
Northern Ireland  12, 16–17

*Once Upon an Alphabet: Short Stories for All the Letters*  57–58, *59–61*, 83
*Our Place in Space* (installation)  96, 97, 102, 104

*Peanuts* (Schulz)  13
Pearson, David  87
Penguin US  25
*Le Petit Nicolas* (Goscinny & Sempé)  13
poems  16, 17
Point du Jour  16
posters  *22*
Premo, Mac  14, *15*
*PRINT* magazine  16
*Protracted Landscape No. 6*  64
publishers  24–25, 71

Schulz, Charles  12–13
Sempé, Jean-Jacques  13
sketchbooks  *8–11*, 20, *105*
Smartt, Stephen  97
Song, Haein  75
*Stuck*  48, 51, *52–53*
Summerskill, Sam  71

*The Terrible Thing That Happened to Barnaby Brocket* (Boyne)  69
*There's a Ghost in this House*  91, *94*, 95
*This Moose Belongs to Me*  51, 54, *55–56*

U2  70
Uderzo, Albert  12
Ulster University  17
*Understanding Everything*  63, 64
*Up and Down*  28, 44, *45–47*

Waldron, Kevin  104
Walker Books  71
watercolour  28–29
*The Way Back Home*  28, *38*, 39
*What We'll Build: Plans for Our Together Future*  87, *90*, 91, *92–93*
*What's the Opposite?*  54, 57
*Where to Hide a Star*  28, 104, *105*
Winston, Sam  71, 73
Wyeth, N. C.  62